THE Soul
AND OTHER
Essays

ROBERT W. DUNNE

authorHOUSE®

AuthorHouse™
1663 Liberty Drive
Bloomington, IN 47403
www.authorhouse.com
Phone: 1 (800) 839-8640

Published by AuthorHouse 09/23/2015

ISBN: 978-1-5049-5094-7 (sc)
ISBN: 978-1-5049-5093-0 (e)

Library of Congress Control Number: 2015915380

Print information available on the last page.

Any people depicted in stock imagery provided by Thinkstock are models, and such images are being used for illustrative purposes only. Certain stock imagery © Thinkstock.

This book is printed on acid-free paper.

CONTENTS

ONE

Introduction

I thought of many different ways to begin this piece. One time I envisioned this work as a daily notebook in which I would record my thoughts of each day. Another time I pictured it as a kind of platform through which to express my changing moods. Still another time I saw this as a means to express my highest philosophical ideas. As I think of it now, these are all different ways of saying pretty much the same thing. This will be a statement of the world according to myself. (I have decided to break it up into a series of essays.) As you may imagine, to set out to write a piece of this sort leaves open such a wide diversity of topics. It is hard to know where to begin. Perhaps it would make sense to begin with the matter that is most important to me, which could best be described as the things of the "soul." I learned in a philosophy course that there are basically two types of outlooks on reality. There is monism and there is dualism. Monism states that there is only one type of substance in the world. In present day thought that substance is seen as physical material, and the philosophy is called materialism. Dualism states that there are two separate and distinct substances in the world, matter and spirit. The soul is not made of any material substance but is wholly spiritual: immaterial. The reason why materialism has inherited the earth is that dualism has a basic problem inherent: How does an immaterial substance have any

effect, any relationship with matter? Material things can be seen to move each other but immaterial substances don't seem to have any way to interact with the material. To the material scientist, the spiritual is unreal, has no existence, it is made up of dreams and fantasies. There is no "soul." Can you locate it? Can you describe it? Can you explain cause and effect with regard to the immaterial? We are left to say "no" to all of these questions. Whereas in the past we saw reality as the whole of things, now we see it as bits and pieces of subatomic particles. The soul is defeated by virtue of the "fact" that it doesn't exist.

So I must be strong and straightforward and assert that my primary goal in life is to rescue the "soul" from non-existence and oblivion. But science and its underlying philosophy is powerful and I seem to have set myself up against the very mentality of modern Man. Once Man is reduced to chemicals, electric charges and subatomic substances is there any way to put him back together again? Even if I had all the king's horses and all the king's men at my disposal?

I must begin with what is the basic reality we are dealing with. I assert that the materialists have got it all wrong – they've got it upside down so to speak. We forget that the scientists are first and foremost interpreters. They do their experiments and they evaluate the results. It seems plain enough that the results don't interpret themselves, but that a human being is necessary to make sense of every study that is conducted. Do numbers in and of themselves have any meaning? No, they must be interpreted. Does math do math? Of course not. Human beings do math. What is required in any endeavor is that a human being engages

himself in his "consciousness," or the "mind." Without the mind nothing is understood. So what is necessary here is a living human being to study, examine, interpret theories, facts, systems. Without a mind, without a consciousness, nothing can take place.

TWO

The Soul

Some of you may know that in the past we used words like the "psyche," the "mind," the "soul" to designate the source from which all things are seen and understood. It was accepted that there needed to be a being, an agent that thought, saw, and understood. People didn't assume that the realm of the soul was only one of ghosts and spirits, and the make-believe. Yet can I define the soul, the psyche? Can I render it real to my readers? Isn't the soul that through which the individual understands what is? I find it interesting to consider how mankind views the great philosophical questions differently through time. Freud was not afraid to begin with a concept like the "psyche." The ancient Greeks weren't averse to seeing man's basic essence as his mind, "psyche." Where have we gone, I ask, in the present days of modern history? It seems we have calculated ourselves right out of the picture. It seems clear to me that if there is no soul there is no person, and what remains is chemicals, and substances, particles, electric charges. Some philosophers call this phenomenon of the disappearance of the soul "reductionism." Everything is understood only analytically. Everything is reduced to a smaller level of existence so what was initially a whole is now broken down to constituent parts. Involved in this process is invariably turning a whole being or systems into a mechanism and presenting mechanics as the method by which things

operate. The reductionist starts out with a human being of immeasurable value and ends with a collection of parts worth a few dollars. Yet, what is the mystery of the soul? Students of the soul, "searchers" if you will, find the most intriguing, wonderful aspects of the universe in the very soul. Great sages often make a distinction between looking outward into the objective world and looking inward at the indefinable soul which cannot even be put into words. Knowledge of things in the outside world are not of the importance or value of the things within. The customary way to distinguish these two realms is to call the outside things, things of the world, and the inside things, things of the spirit. It was Jesus who said we must be born again. The first birth is the physical, worldly birth where we descend from our mothers' wombs. The second birth is when we choose the realm of the spirit over the worldly realm. The things of true value, the things that really matter are the spiritual things. For those of us who hear the call, nothing has greater value than the spiritual realm.

All the religions of the world have their own prescriptions for living a good, righteous life, a life that puts the spiritual first, that seeks to develop an understanding of right and wrong. One of the first documents that expresses the right way to act is from the ancient Hebrews and is called the Ten Commandments. Many people think these rules are too cut and dried and that living a good life is more of the heart than of the head." Some religious people deal more with the interior of one's being than others do. Religion to me is something basically for children. It provides answers to questions we don't really know the answers to. I might put it this way: There is a lower morality used to teach children

and a higher one that adults use. I use the expression "God beyond God" to describe the realm of the highest spirituality. "God" is beyond any concepts, ideas, or words that would define him. One must give up ordinary concepts of reality and "God" to approach the kind of understanding that higher morality promises.

Perhaps the highest form of adult morality arises in the experience called "mystical." In a mystical relationship with "God," we are one with "God." There are no longer any boundaries between oneself and "God." God and the individual are one. Many people report miraculous happenings during the mystical state. One knows what only "God" knows, one sees and understands what only "God" does. One transcends the everyday world and becomes as "God." Often past, present, and future are one, and one sees with the eyes of "God."

THREE

Likenesses

Descartes, a famous philosopher and mathematician, figured that the soul must have a physical location in the body. He asserted the soul was located in the pineal gland in the brain. But this would destroy the nature of the soul as an immaterial substance. If it can be located and has material dimensions, it is physical, not immaterial. It is hard for many of us to picture the soul without seeing it as having physical dimensions. Yet we must firmly assert that the soul is beyond all conceptions and ideas. It can be understood only intuitively through metaphor and figure of speech, through stories and tales that illustrate what the spiritual dimension is like rather than to actually describe it or posit its nature.

To show the value of his "Kingdom of heaven," Jesus taught that a pearl merchant came upon a pearl of superlative value. It was so precious that the merchant sold everything he owned and bought that pearl. That, according to Jesus, is the value of the kingdom of heaven. Every penny you own, every possession you have does not exceed the value of the kingdom. Notice that Jesus never describes the kingdom in this parable, but he conveys its value. The kingdom of heaven was for Jesus the spiritual dimension as opposed to the physical realm. It is so much higher than anything merely physical.

So what happens when we refuse or neglect to posit the soul as our essence, as our Life Force? We wind up materialist fools who compare ourselves to automobiles and computers and say, "Yes, we are like that." There are many forms of reductionism: There is the mechanics of cars, there is the binary code of computers, there is electricity and chemicals. But what I see at the end of all such comparisons is a big, fat zero. We reduce ourselves to nothing. Our value is nothing. Without the soul, all things crumble and settle down to a mere pile of sand. One common instance of random thinking is the tendency to view ourselves as essentially like computers. We have "hard wiring," we have "software," we calculate, we employ logic and math, we do tasks, etc., etc., etc. Wouldn't it make much more sense to say that computers are like us rather than the other way around? Once again, Man has created a mechanism like himself. Don't we all know that a computer can only give out what we have put into it in the first place? A computer operates by logic, math, and calculation. We have created it in our own image. We give it capacities that we have in the first place. Why do we keep defining ourselves in terms of the things we make? This shows to me a terrible lack of understanding. There are too many "computer brains" walking around. Let us all return to the natural goodness and simplicity that is our heritage. Let us recognize our true nature as beings with souls.

FOUR

Morality

I would like now to examine the question of morality. "Is morality real, does it designate a real process or is it really rather an empty idea that cannot be shown to exist?" We are all taught as children right from wrong, good and evil. The method almost always employed is to teach that doing the "good" thing, the "right" thing will bring some kind of reward, while doing the "wrong" thing, being "bad," will result in negative consequences. In a "God"-based religion, it is ultimately "God" who dispenses the rewards and punishments. Morality is so ingrained in us that we can hardly imagine that right and wrong are not meaningful designations. We view ourselves in these terms. We assess ourselves with respect to whether we are good or bad people. Our consciences are formed to back up the "reality" of good and evil. I wonder how many of us have actually examined what is involved in having and employing a capacity for right and wrong. Let me give an example. Let us ask what is at work when a mother asks her child to pick up his toys off the floor. What do those who believe in morality understand to occur when the little boy obeys his mother and does as she asks? First of all, it is assumed that the boy has the capacity to form moral evaluations. Before a certain age the mother will not consider him to be a moral agent capable of moral acts. But assuming that that the boy is of age, we consider him to be a moral agent. Along with this, we assume he has

developed a conscience that lets him know the difference between good and bad. Perhaps of equal importance is the question of motivation. Does he choose to do right over wrong? Is his act properly morally motivated? If all these conditions are met, then we can say that the boy performed a moral act when he put away his toys.

However, it seems to me that there is another way, a different way, to understand his behavior. We must first recognize the subtle and not so subtle influences of the mother. All along there has been learning of a different sort than "moral learning" that has been going on in this boy's life. He knows implicitly that his mother is his means of survival, and he values her more than anything else in the world. He gets comfort, warmth, sustenance, happiness, interaction, and excitement from her. In fact the mother is practically his whole world. He is sensitive to every motion, word, touch, facial expression that she gives off. When you put together all that the mother represents to the boy, you could hardly say she is anything less than a "God" to him.

There are so many ways that a mother conveys her messages and cues to her son that to enumerate them would be next to impossible.

So then, what is going on when a mother asks her little son to pick up his toys? What message or messages does he hear, does he take in? Does he not detect the expressions on her face? Does he not see the posture she takes? Does he not read her tone of voice? The little boy knows one thing, and it is more powerful than any angel or devil's voice whispering in his ear. He knows what his mother wants of him and knows the value of maintaining a love relationship with his mother. How easily is a little boy crushed to watch

that fun, exciting, seductive smile vanish from his mother's face? Wouldn't he be willing to do most anything to see it come back again? Through the bonding process between a mother and child a love relationship develops that is stronger than steel. Why does the boy do what he is told? Is it out of moral sensibilities or is it out of love and the fear of its loss?

FIVE

Motivation

 With regard to moral acts, one must confront an aspect of knowledge that for me is still in its infancy, and that is *motivation.* It would be hard enough to comprehend if we had only the conscious mind to deal with, but the conscious part of our soul is like the mere tip of an iceberg. Can we ever fully understand our motivation considering that the unconscious is such a great part of our psyche? I grew up having to contend with what to me were unanswerable questions of motivation. People would ask, "Are you looking forward to going back to school now that the summer vacation is over?" "Did you enjoy the movie we just saw?" "Isn't your mother a truly good woman the way she's so concerned about you?" "Billy is such a good boy. He is always so polite." Etc., etc., etc. My point is that everything we do is complicated and involves a mixture of thoughts, feelings and desires and nothing can be reduced to one simple motive. I remember so many occasions when I would consider the motivation of my therapist in his treatment of me. I would think, "He must really care about me. He does all he can just to help me mature and become better able to deal with my problems. Then the "cynical" side of me would think, "Yeah, but isn't he also concerned about himself? Doesn't he benefit from maintaining a clean, lofty self-image, from seeing himself as a "good guy," one who cares about his fellow man? Doesn't he regard himself as

a true contributor to society, and is not all of this a great reward for his ego?" So what motivates him really – concern for self or concern for others? It may be, after all, some mixture of the two, but that would make him shine a little less brightly, than as purely altruistic. Some other factors in his motivation might be the amount he is paid for doing his job, certain material objects he values and intends on purchasing with his money, putting food on the table and a roof over his head. Yes, for me, motivation still remains mostly a mystery.

It strikes me that if motivation is so complicated and difficult to understand how is it that we so facilely speak about right and wrong, good and bad? Does not choosing right from wrong involve an implied capacity for moral action? Does not being capable of moral action imply a meaningful understanding of morality? Yet, we are still in the dark if we cannot do any better than to say that motivation is not so clear. What is it, after all, that is at the base of moral choice? How do we know right from wrong?

I would now like to address the issue of intent. Intent refers to the thing we look toward doing, we plan on doing. Most people think of morality as boiling down to intent: that which one sets out to do. If one sets out to help a friend but circumstances get in the way, we impute to him moral goodness for his desire was to do good.

Likewise if one sets out to harm another but something intervenes preventing him from carrying through his intention, then he is imputed with an evil act. His *intention* was to harm.

Another way of putting this is to say that what is in your heart is what matters. The basic problem with this type of

thinking is that we can't really know the nature of "good" and "evil." As much as we may want to do what is "good," by what method of thinking or analysis do we come to the knowledge of right from wrong? If motivation and one's particular intentions are decidedly mysterious, are beyond our ken, we must admit our ignorance and come to no conclusion.

The ancient Jews may be particularly instructive here. They believed that man was quite limited when compared to God. Things of real substance and deep knowledge were kept from man. Man could only know so much. God's thoughts were said to be higher and more lofty than man's thoughts. When it came to morality, man didn't really know right from wrong. It was only through the revelation of God through the prophets that man could ever know anything of substance. God spoke through the prophets and that is how we know what is what. However, I believe I know things only through my own experience. I can't know something secondhand after it goes through someone else. For me to know the key to morality, God would have to reveal it to me himself. Yet God is silent.

SIX

The Psychology of Christianity

I would like to turn now to Christianity and the question of just how it is that Christianity comes to be believed in. What is the stuff of faith after all? For many believers, it is a matter of being reconciled with and convinced of the doctrines of the religion. One sees the ultimate truth of the teachings and comes to believe in his heart the essentials of the faith. Christians believe a transformation occurs within the soul once one accepts God as Father and Jesus as savior. Jesus died for our sins and thereby atoned for them in a way that we are unable to do ourselves. Yet, my question is not so much a matter of what Christians may believe but how does Christianity come to be efficacious within each individual? What's at work within the individual that causes him to embrace the Father, the Son, the Holy Spirit, the notions of sin and redemption and all of the doctrines of the religion?

My question is a psychological rather than a spiritual or religious one. One need not be very sophisticated to realize that most Christians are found in the West, Hindus are found in India, most Muslims are found in the Middle East and Asia, and that the official nation of the Jews is Israel. Of course, there are many secondary factors, but the primary reason people of a particular religion are found in particular areas is because that is where the religion is mainly taught. If one wants to put his finger on the primary means of

producing an individual of a certain religion he needs to indicate where it arose and how the "truth" is taught.

Now, of course, we all know of many failures in raising children up religiously. I would like to examine why there are such failures and what goes into the production of the successes which are the majority of cases. Since I was raised Christian, it is easiest for me to deal with this matter by examining the Christian religion. I am quite sure that my examination will apply equally well to other religions. To start out with the major concept that makes the religion work, I will speak of love. The verse that comes immediately to mind is found in the New Testament and is simply, "God is love." If we want to know what is truly at the bottom of our religion and is also a good definition of God himself, we need to understand "love." I remember I was taught in school by a Catholic nun that "love is the outpouring of self upon another." This is the height of Christian virtue, to love one's neighbor. By the same token we were taught that God loves all of us so much that he gave his only begotten Son to redeem us for our sin, to atone for our transgressions. Greater love than this does not exist. Only God can make such a sacrifice. As an indication of the importance of love, we were taught that the true path to God was that of the heart and not that of the head.

One can see how the necessity of loving one's parents flows directly from the value placed on love. Our parents would do anything for us, protect us, feed us, keep us warm, clothe us, house us and most importantly to bond deeply with us to indicate how much we are loved. How can we not reciprocate by loving and obeying them in turn? They are our caretakers on a human level.

Let us examine further this relationship of love between parent and child. Are not our parents regarded with the highest trust, the greatest reverence? Do we not have great hope that they will come through for us, will satisfy our needs? As I think of this bond, I see something very natural and good. Is it not because of the flow of Nature, rather than anything metaphysical that is at work here? Is love a moral act or rather a natural process like that which motivates the mother elephant to defend her offspring?

As I continue now to explore the psychological nature of religious belief, I want to be careful not to be a reductionist and merely take apart religion without putting forward a full alternative system. However, there is much more work to do, so let me continue.

With concepts such as guilt, resentment, vindictiveness, forgiveness, and non-judgment, the teachers of morality touch upon very real parts of our psyche. The religious teachers hit us where we live. What religion talks about as moral concepts, one can see as simply very real aspects of the human soul. One deals with the negative side of our existence when he gives religious definitions to these concepts. However, religion is not the only way to account for these basic human concepts. Is it possible that we have just now found some of the real motivators of human thought and action? An unforgiving heart will pay for its refusal for indefinite periods of time. When an individual detects slights much of the time and responds vindictively, this is a good sign that his sense of wellbeing, confidence, and self-worth are operating at a lower level than is optimal.

Qualities such as sympathy and empathy are cherished by Christianity as well as secularly. To be able to feel another's

feelings, to identify with his hurts and feelings is a talent high up on evolution's ladder. Many psychologists value these qualities as much as Christianity does. Some therapists think it is their main job to indicate to the patient that he understands him, can identify with him, that he "feels for him." In one type of therapy the therapist simply mimics or echoes the patient: "Doctor, I feel a little unmotivated lately." "Yes, you feel unmotivated." "I feel sad." "Yes, you feel sad . . ." Perhaps there is nothing more powerful in our makeup than the feeling of guilt. We are totally at odds with ourselves when we are caught in the throes of guilt. Is this not as much psychological as spiritual?

Apparently one is not himself. He has one vision of himself that of an acceptable, good person, who tries to get along with people, and another which is negative, mean, lacking in basic social skills, and has performed a deed that doesn't seem at all like himself. We don't like ourselves. We are acting like someone else. Most importantly he is scared, sorrowful and doesn't feel like he belongs. Using Christian terms, he sees himself as a sinner, someone who has transgressed against neighbor and against God. He feels the need for forgiveness and atonement. One feeling I haven't yet mentioned is the feeling of being sick. One feels that there is something wrong with him. The Christian in him interprets this feeling with not being right with God. In psychological terms, he is feeling unhealthy and short of being whole. He recognizes that he is not always performing as he'd like to and he feels motivated to improve himself so he can once again feel well.

One final human tendency I'd like to deal with is fear. When we feel threatened, not for a specific reason, but in a

generalized way, when we sense a need to defend ourselves in some way, we may want to ask, "Just what is it I'm afraid of?" If we are inclined toward a religious explanation, we may conclude that "evil" is threatening us, or the devil or his demons. We feel powerless. We are being attacked. In a more psychological mode we may feel that we are encountering chaos. Our world is breaking down, our very core is unsafe. In both cases we may feel our "soul" is being attacked. Yet, is the soul made up of Christian virtues and Christian sins or is it made up of all that makes us human? Is the best way to describe the soul as "consciousness"? Or is the soul the moral report card of all our behavior?

Let me go further, deeper. Just what is it that Christianity attempts to deal with that, perhaps, is better rendered through a psychological understanding? Is the answer the "Natural Man"? I think it would be helpful to zero in on two concepts I previously mentioned, love and guilt. The importance of understanding these concepts is agreed upon by both the minister and the psychologist. Without a deep comprehension of these concepts neither religion nor psychology could put forth a picture of man that is complete. Love is what is good about us, and guilt is what occurs when something goes seriously wrong.

The capacity to love is one of the primary indicators of a healthy soul. It underlines the loving of oneself as well as the loving of others. People who do not love themselves feel dislike for themselves or in the deepest degree, self-loathing. Their attitude is negative, they become cynical, they don't reach out, have little trust for others. They are the "sick-souled." People able to open up to others, to share positive feelings, are more generous, kind, compassionate

and trusting. The quality of life is so much better when we love.

Those steeped in guilt blame themselves for acts that may or may not be wrong in any way. They have a poor self-image, consider themselves transgressors, are unable to reach out, and are always looking down upon themselves. So whether one views a person as a psychologist or as a minister, one can see that people high on the scale of loving and low on the scale of feeling guilt are much better off than others. Here, I think is a good place to start in devising an outlook in which the viewpoints of secular and spiritual are roughly the same. Whether we refer to the "healthy individual" or the "good person," we are talking pretty much the same language. What causes us to love and what reduces guilt is healthy. What goes on in us that promotes a loving spirit is to be desired. Associating, for example, with others generally promotes a more loving person and reduces the feelings of guilt. Staying to oneself too much of the time results in a person unable to love and one who is feeling guilt much of the time.

Acting in ways considered religious are often also healthful in a secular sense. Certain behaviors *work* in producing a well-adjusted, happy, "sinless" individual. One falls into all sorts of "sins" when he neglects to live a loving and forgiving life. Stinginess, hate, possessiveness, vengefulness are all qualities that make for less than an optimal way of living. Whether we call them "sins" or as the Buddhists do, call them examples of "unskillful" living, the same part of our psyche is involved. If something *works* in producing a loving behavior, it is "good," desirable. It will be promoted by minister and psychologist alike.

My overall goal in this section is to establish what real part of the psyche is involved, worked upon, changed in the process of what is indoctrinated by a particular belief system, in this case, Christianity. What are the actual effects of Christian indoctrination on the psyche, and does this process work? What happens to the virgin psyche as a result of this indoctrination? In other words, how does a particular religion *work* in terms of what happens to the psyche? Do not mental, emotional and spiritual health arise from belief in a good God who loves us, and whom we can trust to forgive us for our wrongdoing? We build a satisfied, happy individual through certain beliefs we take on when following religious teachings. The depths of the workings of the Christian religion on the psyche is an escape from self-doubt, self-condemnation, and hatred of others where we follow the example of Jesus. He redeems us, rescues us from a cynical, negative personality, or soul. As well, we are strongly influenced when we try to reject the teachings. Perhaps guilt is in the final analysis the great motivator that exists in both spiritual and secular outlooks.

We've examined the power of love. What about the power of guilt? It can make us either snakes or angels depending on how we deal with it. When guilt moves us toward acceptance of God's redemption, we are healed. When guilt pushes us into a self-made prison, we become like the demons. We feel the effects of rejecting our indoctrination. We may discover new points of view but can we escape the pit of self-condemnation?

So, on the positive side, religious teaching gives us positives like love and forgiveness. However, on the negative side, it brings us self-hatred and the prison of guilt.

Robert W. Dunne

One way of understanding the effectiveness of religion is to consider how long a time it remains with a population once established. We're talking about thousands and thousands of years. If a religion did not work in a powerful way in the sense of affecting our real psychological makeup, it would hardly catch on. It wouldn't remain in the population as it does, yet it attaches itself to our psyche so effectively that once established in a certain culture it can hardly be eradicated. Perhaps some people assume that religions are effective because of the supernatural power behind them. However, I think there is a much more human explanation.

SEVEN

Moods

One aspect of the human psyche is the ever-changing reality of moods. This factor has been quite troublesome to me in my daily functioning, as well as my overall understanding of myself. "I'm a little depressed today," I might say to myself. "Today, I feel good, happy," I might say. There are all manners of mood levels in between these two, as well. "What's going on with me?" There is some sense within me that I ought to feel the same all the time. Yet this sameness eludes me, and I catch myself feeling different from the way I did yesterday. What is normal? How should I feel? When does mood change become a matter of psychical sickness? I've spoken to my mentor about this, and he told me that the mood is not fixed. It's changing all the time. We all have our ups and downs. That's a part of life. I think he's right, but I've noticed something about my moods that makes them more than ups and downs. In fact, they seem to have a life of their own. They conflict, they battle against each other. Each mood tries to be dominant. Each mood seems to be a new perspective with its own philosophy. My mood changes, and the world changes. I have wondered if this phenomenon is the result of merely thinking too much, of going too deep. This may be so, but I'm still left with a psyche that has no ultimate integrity.

First, the world is of a certain nature, then everything changes and the world is of a different nature. I have heard

brief statements of truth that account for this changing nature of things. One is "the world is in flux." Another, "You can't step into the same river twice." The first saying indicates that reality is always changing. The second, that the river is not solid like concrete, but is in continual motion, never the same from one moment to the next. Our minds are likewise always in flux, always changing. Some people think that the mind does remain the same, but that it is such that it has different characteristics. They talk about happy, sad, anxious, sure, calm, stressed, hopeful, despairing, etc. The person is the same. It's just that he has different emotions. However, for me, the various moods go very deep. A distinction needs to be made between healthy, holistic functioning and that which we call "ill" or "sick." Many people fall into moods that are fairly inescapable. These moods put off all contrary feelings and one is stuck in one way of feeling. The variability I have been writing about is not present. Everything is dark, gloomy, unproductive, and lacking in drive or motivation. Things that normally are easy become hard to accomplish. Taking basic care of oneself, washing, shopping, getting exercise are a struggle. One is stuck with the belief that this state cannot, will not change and becomes hopeless, forlorn, morose. The natural vicissitudes of life are not present and one simply gives up. Thankfully, medical science particularly, in the recent past, has developed methods to alleviate such suffering. Through the breakthrough of modern medicine, chemical substances have been invented that help to bring the patient out of the depths of depression. Together with talk therapy these substances restore to a high degree one's normal experience of moods.

It is important to mention that there are various types of mental disorder that medicine and talk therapy will treat.

When one examines the moods one may be left with the question, "What are we then, after all?" What makes us what we are? Unless we are studying the abnormality of a fixed mood, we experience continual changes. Is there nothing immutable, solid, fixed that we can call our self? Is there no self there after all? What then makes us what we are? There are words like "individual," and "person" that we use to distinguish one human being from another. Yet these terms seem to cry out for definitions. Is it satisfying to say that my true nature has no self, is continual motion?

EIGHT

The Spiritual

There is a body of knowledge that involves matters beyond the everyday things of comprehension. We call the realms beyond the physical the spiritual. The spiritual deals in matters outside of science. The spiritual is also called immaterial. Can we come to know the spiritual or is it always beyond our ken? Religion begins with the premise that the spiritual, the supernatural, is indeed real and more profound than anything merely material or natural. The true realm of being for the religious one is the spiritual. By what faculty or manner do we come to know the spiritual? For the religious the spiritual is a different realm and through spiritual knowledge or comprehension we can come to know it. Is there, then, a spiritual faculty by which we know such things? We seem to revisit the problem of dualism. Where is the spiritual faculty located? What is its size? How can an immaterial substance interact with a material or physical substance? The religious one must simply say that we have the ability to understand the spiritual. How we do it, we don't really know. How else can we look at it? I asserted earlier that the basic nature of a human being is the soul. We are beings with a mind, with consciousness. Suppose it is simply one of the capacities of the mind to understand the spiritual. Our essence is not material but immaterial. We are beings who understand. The door to the spiritual is not closed. There is a higher "seeing," if you will. One

made possible by virtue of what we are, what we are capable of doing.

I must say that I wind up with contrary answers here. How do I know which is correct? It depends upon one's basic understanding of the nature of Man. Are we souls or machines?

I can also conceive of a point of view that relies not on the question of dualism but deals with the matter: What do we know? What can we know? When it comes to the matter of the higher things – Is there a God? Do we have a soul? Is there a material and spiritual realm? What is the nature of the beyond? Is everything fated? Do we have the ability to choose? Etc., what can we say about them? Can we give answers to such questions? Are we able to say anything at all? One position I have grappled with is the one that asserts: "I am in a state of not knowing." Such matters are beyond my ken and I'd best just keep my mouth shut about them. Is "not knowing" an acceptable answer? Perhaps, it is the most honest answer of all!

The Buddhist religion deals with the concept of being empty and of being receptive to teaching of the truth and reality. The Buddhists tell a story: A well-dressed gentleman enters a monastery and asks to speak to the leader. He is brought to the leader and has questions he wants to ask him. He has dabbled in Buddhism and is looking for some answers to questions of the nature of reality and the means of finding such a reality. The Buddhist monk greets the man with a big smile, and they converse for a brief time. Next, the monk presumably to show courtesy gives the man a cup and starts pouring tea into the cup. The handsome gentleman is pleased and feels respected by

the monk. But then the monk does something out of the ordinary. He pours and pours till the cup is almost full. Yet he doesn't stop. He continues pouring till the cup is overflowing. Eventually the tea is spilling all over the floor. The gentleman is perplexed and remarks, "Sir, you are over-pouring the tea. It is getting all over the place." Finally, the monk answers, "This cup is like your mind. It is so filled with ideas, concepts, beliefs, opinions so that there is no room for you to receive my teachings. What can I impart to you when your mind is already made up? The gentleman became quickly embarrassed and got an inkling of what the master was telling him. We must be open and empty to receive the teachings of the master. Our preconceived notions simply get in the way of learning.

Speaking of Buddhism, it would seem relevant to speak of some of the main aspects of Buddhist life. Some may believe that the most important aspect of Buddhism is the quest for enlightenment but I believe that the quality of compassion takes precedence in Buddhist life. Buddhism would not be what it is without its emphasis on compassion. It is certainly of more primary significance in Buddhist study. Buddha himself said, "Hatred is never brought to an end through hatred. Hatred only ceases through love." He also said, "You must love your neighbor in the same way and to the same degree that an only child loves his mother." The further developments of insight, understanding and finally enlightenment cannot take place unless we first have compassion for our neighbor. Many techniques are taught to bring our compassion and empathy forward.

There is a special type of Buddhist who pledges to devote his entire life to the compassion of others. He is

called a Bodhisattva. Rather than experiencing the bliss of enlightenment all to himself, he makes it his mission to alleviate the suffering of others and to bring to them the joy of life.

So, let us be filled with the spirit of compassion and sympathy and not give in to the temporary thrills of opinions and beliefs, this or that perspective, and the things that promote our ego. "Hatred ceases only by love. This is an ancient law."

The Buddhist master as all heads of organizations possesses ultimate human authority. When one seeks the definitive answer to a question, one goes to the master and he will provide the answer. Businesses, all churches, schools, non-profit agencies have leaders with the final authority. They provide the decisive answer to matters that involve a dispute. How do we understand authority? How do we recognize authority in our lives? Do we simply accept that the person with ultimate authority is the one that must be dealt with in a particular situation, or do we believe he has actual power and the right to decide in various matters? Jesus asserted that all power and judgment has been put into his hands by his Father. In this he claimed supreme supernatural power. However, Buddha told his disciples to experience things for themselves. What you deem to be true is what you will believe in. Do not believe in me simply because you look up to me, or because I wear a certain style of clothing or because I speak decisively. Believe in my teachings because you yourselves have experienced them to be true. According to Buddha, each disciple is his own authority, but for Jesus he himself is the only legitimate authority. Buddha believed we should not look toward

others to discover the truth of things but should look only to ourselves.

Even though I have no opposition to sensuality and love-making, I have a strong spiritual side. I have explored many religions and to be quite honest, I was a firm believer in Jesus Christ and the teachings of the Catholic Church when I was young. I have spent much time trying to work out my beliefs and attitudes toward Jesus in my adult life. Jesus is to me a man, a natural man, who had a great capacity for love, understanding, and refraining from judging others. All the miracles and supernatural events attributed to Jesus and those around him are to me at bottom, myths and stories to present him as more than human, but as "divine." I no longer believe in the divinity of Jesus. Why should this, however, take anything away from the respect and honor I hold him in? In fact, it rather accentuates his greatness and glory. Here was a man, a pure, natural man, who dedicated himself totally to God and the matters of truth. He devoted himself toward the love and healing of others and gave of himself completely. Even when he had presentiments of his own coming death, he refused to give up his beliefs. He lived out his personal philosophy to the very end. It is for this reason that I consider him a heroic figure. As Buddha had said, "Hatred ceases only with love. Hatred never by hatred ends." I have spent countless hours trying to come up with a version of the Jesus story that is true both to the gospels and the natural truth. Eventually, I had to give up this attempt for I was unable to envision a Jesus that stood clearly without contradictions. I have become satisfied with the version I related above and found I can get good spiritual teachings from many masters.

One idea that for a time satisfied me was that, while Jesus was a natural man and was born that way, through his studies and experience, he developed a consciousness that was quite superior to the average man. He, in a sense, "became" divine, and he set about to teach others to reach their potential and become divine as he had become. "Follow me!" he beckoned. "Do as I do, and you will become like me!"

One thing is for sure, no one living or dead has filled my soul like Jesus has. And even still I sometimes find myself thinking of him and realizing my great love for him.

I have found that studying the teachings of Buddha has helped me to understand Jesus better. In many ways they thought alike and spread the same truths. While Jesus' teachings are somewhat limited compared to Buddha's teachings, one helps clearly the understanding of the other. Where there is the sense in me that we need more teachings from Jesus, Buddha nicely fills in the rest.

The spiritual domain for me is not now dominated by authority figures but by spiritual understanding that reaches to the heights. Men, for me, are more like vessels that contain deep truth. The individual men need to be transcended to arrive at the ultimate truth. Religion makes them "God's" supreme masters. The individual soul must rise up with a path to the Supreme without becoming attached to one special man. In this sense, my love of Jesus is fine so long as there is room for love of other teachers as well. But once I make him a God I'm left with the bad fruit that bad trees bear.

It strikes me that God would not be much interested in our praise and worship. I think that first of all, he's pretty

sure of himself and needs no propping up. He has integrity beyond what any human has and knows within himself his standing in the world. Also, I can't help thinking that he'd be enormously embarrassed by praise and worship. I imagine him saying, "I am fine as I am! What need have I with all your brown nosing and buttering up? Would you applaud me for all I have done? I don't think I could tolerate it."

I once came to the conclusion that there were no capital T truths, that in fact, when it comes right down to it, all we have is perspectives, various perspectives. It's as if we can look at a thing from one angle or another. We have various philosophical viewpoints that regard our issue in many different ways. No one viewpoint is correct, the others being incorrect. They all have an integrity of their own. Perspectivalism. That's what I called it. However, at times, I find myself questioning perspectivalism. Is there not one perspective that is more than a perspective, but the really right way to see things? Is it not possible to escape from the various perspectives and rise to a higher truth? In ancient days it was respectable to believe in truth, that there was one correct way to see things. Perhaps this amounts to a God's eye view. But then, who of us can see from a God's eye view? I don't know. It seems the more I try to understand things, the less I really know.

Can we ever really understand God without the use of metaphors and similes? One example that comes to mind is the word, "Father." God is like our father. He cares for us, provides for us, teaches us, leads the way for us. With good reason, Jesus chose the metaphor of "Father" for God. Another example of metaphor is Son of God. Jesus was

like the son of God. He was God's child, so to speak. He was loved and chosen for a very special chore: to lead the people out of ignorance and sin into understanding and the light. Look! I have just used another metaphor! "The light." Light is the opposite of darkness. Darkness symbolizes not knowing, being ignorant, being confused and doubtful! However, the light represents knowing, seeing, being bright and clear not merely literally but in our minds. God is like the light; God is the light. Jesus saw it as his mission to reveal to others the "light of God." "God is a mighty fortress." With him as our defender, how can we lose when in any confrontations in life?

So what is the nature of a metaphor? It is when one thing unlike another thing stands to represent or stand for the other thing. For example, "He is a lion when it comes to getting his way." We don't mean to suggest that the one referred to is literally a lion. We mean that in the same way that a lion commands and demands his way and satisfying his will, the person spoken of commands and demands that he gets his way in what he desires. I recall from a poem I once read the expression "leaden skies." The skies are not to be seen as made of lead but to be seen as dark and heavy like lead.

What all this means for me is that we cannot posit a literal meaning for God. The best we can do is to use metaphors and similes.

It may seem contradictory but I believe that the soul in its best state is empty. It is empty of words, thoughts, feelings, concepts, ideas, beliefs, you name it, the soul contains none of it. That is, in the optimal state. Of course, we cannot survive and function in this state all the time. It is more

of a breather, a refreshment, a time out when we are at our highest energy level, paradoxically. The Buddhists reduce the human functioning to two basic activities: breathing in and breathing out. What I am talking about is akin to meditation. I call it "positive non-thinking." Many people think we are filled with energy when we are entertaining heavy notions, doing strenuous things, exerting ourselves in one way or the other. Rather it is in the absence of exertion when we are at our highest level, strongest, most honest and true, and dedicated to higher values.

What is it like when the soul is full? We are rigid, certain, arrogant, and knowing. We've got things all wrapped up, we are filled with concrete ideas and notions. Though we may think a mile a minute, our thinking amounts to little. When thinking is, in the end, fixed, there is not much going on at all. The Buddhist way is to let all thoughts, feelings, and ideas pass into consciousness and then pass right out again. We experience it, note it, and then let it pass on by. This is a cleansing process. The soul is truly full only when it is empty.

These interludes of positive non-thinking bring freshness and rest to the soul. Rather than being a non-entity in this state, the soul is supreme, wondrous, and beautiful.

A breathing exercise that aids in reaching this state is more or less the foundation for meditation. Focus on breath. Slowly breathe in, then breathe out and count "one." Then do this again and count "two." Continue all the way up to ten, and then start all over. As thoughts, ideas and feelings come into the mind, let them go. You can think in this positive non-thinking way for about as long as you wish.

There is a saying in the Tao Te Ching: "Empty and be full. Yield and overcome. Bend and be straight."

It is not in being filled up with beliefs that one reaches the highest sphere. An American M.D. formed a theory on Buddhist meditation and called it the Relaxation Response. This is what I'm talking about. It works on a physiological level and though it is aided by Buddhist philosophy, it does not require it. It is all about relaxing.

NINE

Evolution

It strikes me that there are basically two types of people who make conclusions about the origin of Man: There are those who believe in static creation of all that exists, the mountains, oceans, sea life, animals, mammals, all living creatures, including Man; and then there are those who believe in an evolutionary beginning of all things and all life forms. It seems clear to me that all that is from the astronomical realities to earthly things, including mountains and oceans to animal forms, and all forms of life, are what they are through the process of evolution. So many fields of science bear out the truth of evolutionary change. Forms were not created fixed by God but cause to be what they are through the process of evolution. An historical figure, an archbishop, once calculated that the earth was about 6,000 years old and that the first man, Adam, was born 4,004 B.C. However, we now have scientific instruments and dating devices that posit that the earth is billions of years old and the universe is about 13,000,000,000, 13.B years old! Also, there exists fossils of prehistoric Man 100,000 years old to fossils of early ape men almost a million years old. It seems those who get their answers from the religion are out of touch with reality. Simple facts, using human tools, point out that static creation is not the way things happen or ever in the past happened.

Part of the problem here is that evolution often takes millions or billions of years to make changes in objects and life forms. We can't observe evolution in action in the moment. It is something we must realize through thought and theory.

One method of "observing" evolution is to study similar anatomical parts in similar life forms. We can see how some life forms are related, as well as the time involved in different species becoming as they now appear. There are several pre-men who show differences in form in terms of where they existed and where they are on the evolutionary scale. There are Peking Man and Java Man, now called Homo Erectus. There is Neanderthal Man and Cro-Magnon Man. These are all Man-like but not quite as evolved as Homo Sapiens, us.

One fascinating object of study that shows evolution at work is the stage of the stars and how they appear. The color, size, and age of stars all tell a story of their evolutionary history.

The static theory of life is really no more than a Bible story taken literally and used as a means to understanding the universe. It is the story of the seven days of creation, the birth of Man, Adam, and his helpmate Eve. Step by step God created the universe and everything in it. The story of evolution is quite different and appeals to minds, perhaps more sophisticated than those who believe in Bible stories.

Just as a final note, I would like to say that evolution and early Man became a fascination for me when I was around 12 years old. I sent away for several books in the Time-Life series and happily read away. I remember especially the man who was most known for his archeological studies and

anthropological work on early Man. His name was Louis Leaky and he excavated mostly in the Olduvai Gorge in Africa. He was one of my early heroes. I couldn't get enough of his writings on evolution and early Man. I dealt with the conflict between evolution and God's creation in the Bible. However, there was no doubt in my mind that evolution was real and true and that the origin of Man was quite different from what was told in the Book of Genesis.

TEN

Metaphysics

The spiritual is sometimes called the metaphysical. It originally got its name because Aristotle, after writing his volume on physics wrote about that which came next, metaphysics. It had no other meaning than that it came "after" physics. However, it has come to mean that which cannot be discerned through science and rational thinking. It is somewhat akin to the supernatural, that which is beyond the natural. Religion deals a great deal in the supernatural. This is what has to do with God and all things non-natural. If we come to a conclusion or work with a theory that cannot be put into rational thinking, that deals with this "beyond" we are talking metaphysics or supernatural. For many, metaphysics is the realm called the paranormal, strange or eerie happenings that occur beyond the physical world that cannot be measured scientifically. This deals in ghosts, the hereafter and other such things.

For me, there *is* a realm called metaphysical but I don't know if I can know anything about it. It seems to stretch beyond my thinking so as to be beyond my comprehension. However, I do believe in the spiritual domain, and I think Jesus put his finger on it when Pilate asked him if he were a king. Jesus answered, "My kingdom is not of this world." I believe I have the capacity to comprehend and meet the metaphysical through my inner experience. It is not a thing of rational thinking but rather it is a thing of inner

understanding. I "know" Jesus, Buddha, and other figures I call Masters through inner comprehension. My capacity to love unconditionally is rooted in the metaphysical.

For many throughout history metaphysics has been understood as a special type of knowledge that only the initiated can know. There is a broader organization and you must pledge an oath to be considered worthy to know the truths of metaphysics. Knowledge is considered to be secrets revealed only to those on the inside. For me, I am entitled to know whatever I am capable of discerning. There is no authority above me.

Metaphysics may be thought of as that indefinable reality which is difficult or impossible to put into words. The name for this type of knowing beyond words is "ineffable." Ineffable means that certain secrets are obtainable by me. However, I see myself as a prophet unto myself. Jesus said, "All secrets will be revealed; all hidden things will be uncovered." Metaphysics is clearly more magnificent and essential than anything material. It is the substance that matters.

I would say that the primary figures of speech of the metaphysical are metaphors and similes. I may say, "God has a heart of gold." This is not meant literally, but figuratively. His sense of love and compassion is so valuable that it is worth gold, so to speak. Nothing exceeds the value of God's love. What Jesus perceived few people heard in their ears. This means that when he understood was of a higher nature. Some people are "wolves in sheep's clothing." This is not meant literally, but that they had bad intentions concealed by a good exterior.

Other figures of speech or techniques are used in describing the metaphysical, like symbolism. This is when one thing represents something else. The ark of Noah was a symbol of the good world, the world God wanted to save when he destroyed mankind. Jonah being swallowed up by the whale was a symbol of being swallowed up by hell.

We can't know metaphysical realities directly but only indirectly through figures of speech.

ELEVEN

Consciousness

We, whose essence is the soul, possess a uniquely valuable capacity that surrounds our essence and is our distinguishing characteristic, that being our consciousness. Perhaps it would be difficult to distinguish consciousness from the soul. There is only one problem here that I'm not sure that I can resolve. We are not only creatures of consciousness, we also possess an unconscious mind that plays into our overall consciousness. Perhaps the best way to look at it is to say our subconscious mind together with our conscious mind make up our overall consciousness. No other animal species has a consciousness like that of Man. However, there have been tests that show that chimpanzees have a primitive consciousness and after a time of watching a mirror can recognize themselves. However, all that constitutes the human consciousness is far above and beyond all other animal species. What is consciousness? What does it mean? It means awareness. We can comprehend so that we see the outside world as well as the inner world. It raises us above all that exists in the universe.

For Hindus and Buddhists, there are levels of consciousness in which one understands to higher and higher degrees the true nature of reality. Hinduism believes that the highest truth is the union of the self within with the highest God, Brahma. In this union one has reached perfection. For the Buddhists, the highest consciousness

is called Enlightenment in which the individual attains insight and understanding that cannot be surpassed. The great figure of Buddhism is the Bodhisattva, who sacrifices himself to preaching the truths he has obtained to all the people so they, too, can see as he sees.

Consciousness for me is what gives me the potential to become the best that I can be. I want to love all things, all beings, as well as myself, and this, to me, is the height of the nature and capacity of consciousness. It enables me to be a thinking, feeling, rational, loving being. Without consciousness I am like a dumb animal which doesn't understand itself or what it is doing.

The subconscious is mainly notable for our dreams at nighttime and our fantasies and daydreams. This is clearly connected to the conscious mind and I believe we are informed to a great degree by our unconscious. Perhaps most of our motivation comes from the unconscious. Freud showed how the dreaming of the subconscious is often made up of metaphors and symbols and requires special insight to be understood.

I would like to end with my own personal conception of consciousness. To begin with, consciousness cannot be pictured nor exactly defined. I shall do my best to give a sense of what I mean. One barrier I have at the onset is I tend to picture consciousness as a cloudy amorphous substance, filled with holes and somehow very ghostlike.

It seems to me that this is, in fact, how people picture ghosts. Ghosts can walk through walls, they are somewhere between a solid and substanceless type of thing. However, the consciousness is for me no ghost and has no substance at all. It is totally substanceless. It is immaterial, yet it is the

primary active, dynamic force of one's being. What does consciousness do? What are its talents, skills, capabilities? It enables us first and foremost to think. Without an active, aware mind, we would not be able to think at all. It enables us to string words together to form meaning. It enables us to be motivated to do things. It is the spark that makes us living beings.

When we look deeper into the notion of consciousness, we find that all things of the material world must be filtered through our minds, that nothing truly exists for us unless we are capable of perceiving it. Reality doesn't really exist in the outside world, it exists within us. That is how we give *life* to what appears. When things happen, it is not the event that is so much real, but it is our perception of it. That which is real is actually our perception of things not so much the things themselves.

Perhaps the most striking aspect of consciousness is the various levels of it. We can go from a state which is very quiet and still that is almost like sleeping. Little activity is occurring, but there can be a very positive, peaceful nature to this state of mind. On a higher level, we function at a normal, everyday state, we can read a book with understanding, we can add and subtract figures, we can maneuver our way around what we call the "real world." Yet there is a higher level of being in which we have a heightened sense of what is real and true. We can comprehend deep thought, or to put it another way, "higher" thought. This is the region of high, spiritual existence. We leave behind all ordinary things and merge into the other worldly.

TWELVE

Conscience

Whether it be from the forming of knowledge of right and wrong, or whether it be from a learning of the ways of love and caring, we all form some kind of conscience. In both cases, our parents hold the key. What is the conscience? It is the means by which we ascertain whether we have done wrong or whether we have done right. When we find ourselves alienated from a parent, we feel bad, sick, and guilty. When we do things we know we've been taught are wrong, unacceptable, we feel bad, sick, and guilty. There is also one other feeling involved in doing or feeling wrong, and that is shame. When we feel shame, we feel *we* are wrong, *we* are unacceptable. Our very persons come up short.

There are many theories of conscience, both religious and psychological. The religious theories regard mostly the offending of God. Ultimately, a sin is contradicting God's will. However, we can do this by not treating our neighbor as well as we ought. Jesus said, "Love your neighbor as yourself." First, we must love ourselves. This prevents us from falling into shame. A good conscience arises from following the right path and doing the right thing. We feel good about ourselves and happy, too. When we give to others, this reinforces a feeling of goodness about ourselves. Jesus, in Luke, spoke of many aspects of feeling good about ourselves, and if we practice his teachings, we will feel fine

and wonderful! Jesus said, "Do not judge and you will not be judged. Do not condemn and you will not be condemned. Forgive and you will be forgiven. Love and you will be loved. Give and it will be given back to you."

Of course, there are psychological theories of conscience that have little to do with religion. Freud talked about the "id," the "ego," and the "superego." The "id" is the inner world, the "ego" is the self, and the "superego" is the conscience. We all have the capacity to figure right from wrong at least in so much as how doing right or wrong makes us feel. The "superego" is made up of the "ego ideal," knowing what pleases our parents, and the conscience which tells us individually what is right and wrong.

Jung had his own theory of our makeup which involved archetypes like "mother," "father," "water," "tree," and the collective unconscious, which resides collectively within all of us to inform us of what we learned long ago in the historical past. There is an expression that tells us a lot about the conscience, that has become handy for many of us in describing the workings of the conscience. This expression is "the bite of conscience." When we feel we've really done something bad or wrong, it is as if we have been bitten perhaps by a dog. We feel the pain, we feel bad about ourselves. We feel the "bite." It is a signal that conveys to us that something is amiss, that we've transgressed in some way. At its worst, we feel terrible about ourselves. How do we make amends? Religion was, a way that is readily available. We confess to God that we are sorry for what we've done and we'll do our best not to make the same mistake again.

For Freud, the method of satisfying the guilty conscience was to get in line the "id," the "ego," and the "superego." To

think in terms of what is rational and what will prevent us from experiencing this pain again. For Jung it might be to get in touch with our archetypes and to bring forward into consciousness the truths of the collective unconscious.

As far as I am concerned, dealing with my conscience has been a real rocky road. I have gone from the deepest, hardest conscience to believing that the conscience is a false commodity, that there really is no right or wrong, that conscience is just a byproduct of religious indoctrination, that makes us feel bad, for simply being human. However, I have come to realize that I do indeed have a conscience and that it was formed largely by my parents and religious teachers, and I thank God that I have one. What would I be like without a conscience? What would I believe in? What would I value? Surely, now that I am an adult, the functioning of my conscience is partly up to me, and there needs to be at times some corrections in my conscience. I can always reevaluate my beliefs and values and come to different ways of seeing things.

THIRTEEN

The Kind, Compassionate Person

We all know the difficulty in maintaining a bright, happy attitude in which we put forth kindness and love and compassion to our neighbors. There are certainly times when we are kind and compassionate to others but keeping to it, sustaining it just doesn't seem to be within our capacity. Doesn't it feel so good when we are kind and generous? Doesn't it make us feel more fully human? How true it is that a generous spirit brings great love both to the other as well as to ourselves? It's a win-win situation. We must never forget the goodness of generosity and the fulfillment that proceeds from overflowing love. I remember certain people from my early life whom I considered to be particularly loving and generous. One example is my grandmother, my mother's mother. She possessed the gift of a saint. I remember whenever I visited her, and saw some candy in the cupboard, I would ask her if I could have some. Her answer was always the same: "If you can see it, you can have it." And she was so gentle with us, my brother, sister and me. We all loved her dearly, and I couldn't then fully understand the depth of her love.

I have studied certain Buddhist figures, and it became apparent to me that one of the characteristics of the Buddhist sages was a wonderful compassion. For the Buddhist, the final goal may be enlightenment, but there is no way to get there without a primary practice of compassion. If a

Buddhist has not the qualities of love and concern, he is not a real Buddhist.

In Buddhism, there is a tradition of becoming a very special person, one whose life is devoted to spreading compassion and reducing suffering. In fact, this characteristic has the main purpose of rescuing people from darkness and ignorance and to even be willing to sacrifice himself for the good of another. These people are called Bodhisattvas. There is no sacrifice too great that it be beyond the duty of the Bodhisattva. Their mission is to save another human being.

It would seem appropriate here to mention my mother who did much more for me than even my grandmother. My mother gave me direct, hands-on unconditional love. There was nothing bad I could do that would ever alienate her affection from me. No matter what error I made or what trap I had fallen into, my mother would look at me, and I at her, and there was an unbreakable bond between us. Since mothers have to do difficult things in raising children, she did not come first to mind as a compassionate person like my grandmother; but the more I think of it, there is no one in my life that was more significant, more essential to my life than my mother. In a sense, grandparents get an easier job than parents do. They don't have all the care and concerns for the child, and they can be extra nice to the child. The one person who has meant more to me than anyone is my mother.

I would be remiss in my descriptions of figures of kindness and compassion if I didn't mention Jesus. When I was young, I firmly believed in Jesus and all that was taught to me about him. Some of his most thoughtful teachings

and profound understandings were those regarding love. "Do unto others as you would have them to unto you." "Love even your enemy." "Do good to those who hate you." "Do not resist the evil one." If you fight against evil, you will only pit evil against evil, and this will never produce love. Responding to evil with love brings love to life. Jesus said something to his disciples that Bodhisattvas must have followed before him: "Greater love hath no man than that of one who would sacrifice his life for his friend."

Sometimes, you will find a gem of a person in a package that might lead you astray. I had a nun in seventh grade who we all used to laugh at, because she would come across so tough and tried to rule with an iron fist. But one thing I could not deny: she was as bright as hell. She always knew the material and was determined to try to impart knowledge into our young brains. She wasn't good-looking, in fact, you might say she was rather ugly. Yet strange enough, when I think of all my teachers, it was Sister Mary Joanne who stands out as my favorite. She had the capacity to give her all to her teaching. She put every ounce of love within her to get across her lessons. I'm sure you're familiar with the old saying, "You can't judge a book by its cover." Well, that for me was and always will be Sister Mary Joanne.

In my life, particularly when I was young, I was considered to be a very good person who was kind to most everyone. Much of the time I accepted this praise and did my best to live up to it. Yet, I knew my own mind, my dreams, my fantasies, my lusts, my sexual desires, and I never could make a good distinction between temptation and sins of the mind. I grew up feeling a strong sense of love for people, yet at the same time I had feelings like I was underneath it all,

some kind of demon. I have just recently made progress with my self-image and self-understanding, and I don't think every fantasy or daydream has to be watched for evil. I am human, a decent human being, and I do my best to live a life that is pleasing to my God.

FOURTEEN

God

What is God? Who is God? I have spent hour after hour, day upon day trying to grapple with just these questions. The answers that first come to my mind are those from my childhood. God is all-powerful, God is ever-present, God is all-knowing. Also, he is infinite, immaterial, pure spirit, and partakes not in matter. However, I must say that these answers don't satisfy me much. When I was a child, they gave me all I needed to know. God was real, solid, never-changing, the creator of the Universe. When I now consider these qualities, I'm left with the feeling that I don't know much at all. What is it to know everything as God does? How many things are there to be known? God is all-powerful, but can he intervene into the world of matter? Can he roll a stone that is too heavy to be rolled? What does it mean to be infinite, to have no end? Everything just spreads out forever? So what is the next thing after the farthest thing I can imagine? If God is everywhere, is he in me? Am I God, too? I wind up with more and more questions when I believe in the qualities taught to me when I was young. Can I even conceive of a God who by definition is beyond my understanding? Nietzsche said that we cannot even *think* God. It is not an appropriate topic for our minds.

I find I understand God much better when I approach him from my heart rather than from my head. In the New Testament are the words, "God is love." I give my heart to

God and have a meeting in which God and I love each other. Then I feel I have gotten somewhere. With mutual love, God can truly be experienced. It is the experience of God that matters. I do not so much understand him in words.

I believe that God wants me to love him, to go to him, to give myself over to him. There is no greater love than the unconditional love of God. When asked what was the greatest commandment, Jesus answered, "Love God with your whole heart, your whole mind, and your whole soul." Better words cannot be found for the manner in which we should love God.

For many, it is important to picture God, to see his face in all his majesty. Yet all such renderings of God are made up, created by the hand and the mind. A higher way to picture God is to realize that God is pure Spirit, he has no dimensions, no features. He is beyond any rendering. If you can picture God, then that is not what God looks like. I think the best we can do is to see God in our neighbor. In all the people we meet sits the Lord God of all creation. If you look with love into the eyes of another, then, in a sense, you see God.

I use a phrase to understand how I see God in his broadest dimensions. The phrase is: "the God beyond God." Whatever we can picture, think of, conceive, comprehend, is the everyday ordinary God. However, there is a more truly real God behind this God. He is the "God beyond God."

Our opinions, beliefs, ideas, myths, stories are in the everyday God. We must go beyond this knowable God to touch the real God, the God beyond our ken.

There is a special relationship that some people believe in when it comes to God. This is called the mystical

relationship. For the mystic, one can actually become one with God in the same sense that a man and a woman are said to become as one in marriage. They're no longer two but one. One submerges all his beliefs, feelings, and love in God, and God and you become one thing. The Sufis who are a branch of Muslims believe in this oneness. A person who is one with God shines out like the shining sun, like God himself. I did, however, find a problem with mysticism regarding one's identity. Does one lose his identity when he becomes one with God? Is it good to lose yourself? Is it then only god who does things, God who is in charge? I'm not sure I want to lose my identity.

One final word on God, God the Creator. Is it sensible to think of God as starting the Universe? Of creating the Universe? Where did everything that exists come from? I was taught that God created from nothing. How can things arise from nothing? Did time begin when God created the Universe? Or did the Universe always exist? It seems I can't conceive of a Universe that always existed. This falls into what philosophers call the "infinite regress": things going backward in time forever. Also, I cannot consider myself responsible for my own beginning. I didn't pull myself up by the hair into existence. I must refer to my greatest friend and greatest love, my Creator, my Maker, the Holy God.

FIFTEEN

The Prophet

Many people do not know the importance of the prophet in the Jewish and Christian religions. Some think that the prophet's main ability is to foresee the future and to predict what dreadful things will happen to us if we don't follow God's Word. However, the function of the prophet is mainly to reveal the Word of God. When the prophet speaks, it is as if God was speaking directly to us. The words the prophet speaks are what God wants us to know.

The prophets have told us many things, but the primary message of the prophets has been that we are to take care of the widows and orphans. This is our collective responsibility. We can't be decent human beings if we don't take care of the unfortunates, which also include the hungry, the homeless and the poor. In Christianity, there is more of an individual outlook regarding our duties. Christians don't speak of collective sin or collective responsibility except when it comes to the downtrodden. Those who can't provide for themselves must be taken care of by the rest of us.

Some people think that this means that God wants us to have socialistic governments and governmental programs to care for the poor. However, Jesus never said anything about governmental responsibility. It is an individual responsibility to care for those not well off. There are many ways people can take care of others without confiscatory taxation and redistribution of the wealth.

We are to love the unfortunate, care for them, share with them. What kind of moral choice is it when the state at the barrel of a gun takes your money from you?

The role of the prophet, though the emphasis is on caring for the unfortunate, is to speak God's truth. It is to enlighten us as to what God wants from us. It is to teach us right from wrong, to let us know the true path of God. It may come as a surprise to many but we don't know right from wrong without the prophets revealing to us god's will. The Truth of the matter is beyond us. We need the prophet as the mouthpiece of God to tell us what is true and what is false, what's right and what's wrong.

Isaiah said, "I have called you by your name. I have redeemed you and saved you. You are mine." Perhaps this is the singular, primary teaching of god through the prophet Isaiah. We belong to God. He loves us. He wants us to love him. We are rescued from all manner of degradation and sorrow. We are saved from all our transgressions.

For quite a long time, I have had an issue regarding God's message to Man. It seems to me that when I turn to the prophets to understand God's word, I am getting second hand information. I am not the direct recipient of God's word but rather I am receiving God's word through prophet A or prophet B. I believe I can only know God's will for sure when he talks directly to me. There are questions that arise when I take someone else's word for something. How do I know that a certain prophet was genuine? How do I know he had the legitimate authority to speak for God? What is the true nature of prophet A? Who decides who is and is not a prophet? I conclude that unless God speaks directly to me about something, I don't really know it. I

know what I know through my own personal experience. There is no higher or better communication than the one I receive directly from God.

This is also tied into my conscience. I believe that the final arbiter of what is right and wrong is my own conscience. When it comes right down to it, it is all up to me. No one can decide for me, no one can think for me! In a sense, I am my own prophet! The highest relationship for me that I can conceive of is the one between God and me.

ABOUT THE AUTHOR

Dunne's first career was a singer-songwriter. The first musical group he was influenced by was the Beatles. Sometime later, he found inspiration from the sweet sounds of James Taylor. Due to a car accident, he had to give up his guitar-picking and songwriting. Eventually, he turned to writing books for his creative outlet. He has written twelve books, all of them published by AuthorHouse.

Notes

Notes

Printed in the United States
By Bookmasters